D0574794

The Ship

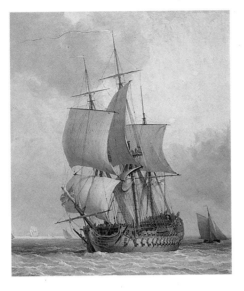

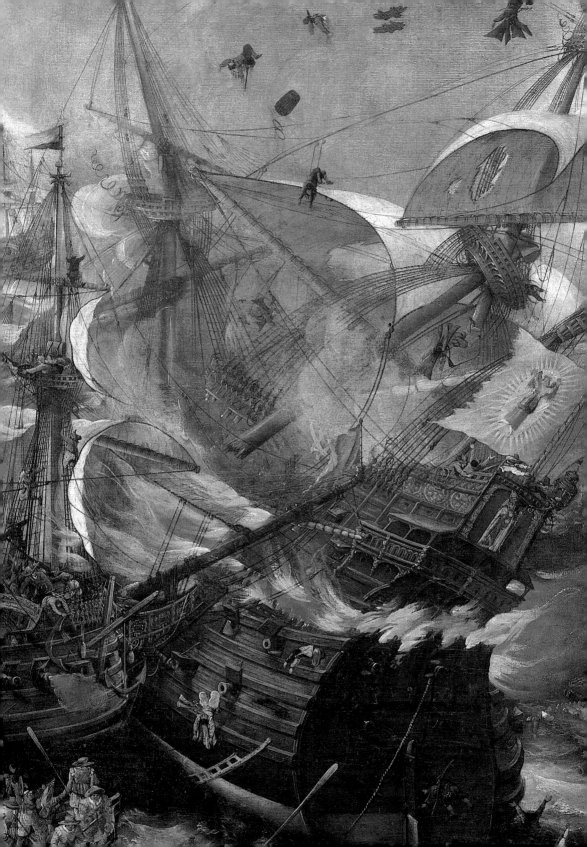

THEMES IN ART

The Ship

ROGER QUARM

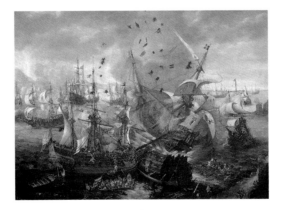

SCALA BOOKS

Text © Roger Quarm 1992
© Scala Publications Ltd and Réunion des
Musées Nationaux 1992

First published 1992
by Scala Publications Limited
3 Greek Street
London W1V 6NX

in association with
Réunion des Musées Nationaux
49 rue Etienne Marcel
Paris 75039

Distributed in the USA and Canada by
Rizzoli International Publications, Inc.
300 Park Avenue South
New York
NY 10010

All rights reserved

ISBN 1 85759 010 4

Designed by Roger Davies
Edited by Paul Holberton
Produced by Scala Publications Ltd
Filmset by August Filmsetting, St Helens,
England
Printed and bound in Italy by Graphicom,
Vicenza

Photo credits: Bridgeman 28; Giraudon 1;
OCMW (Bruges) 4; © RMN 18, 24;
Scala (Italy) 5

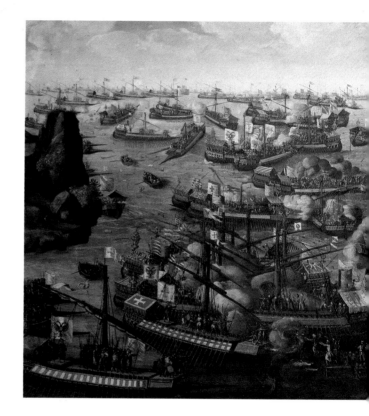

FRONTISPIECE Detail of **19** Charles
Brooking, *Ships in a light breeze*

TITLE PAGE Detail and whole of **10**
Attributed to Cornelis Claesz van
Wieringen, *The battle of Gibraltar*

THIS PAGE **9** H. Letter (possibly Hendrik
Cornelisz Vroom), *The battle of Lepanto*

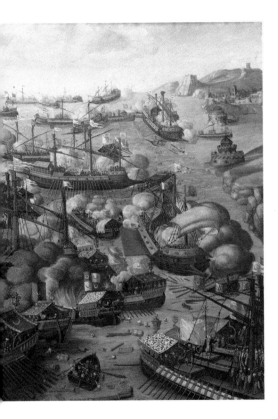

Contents

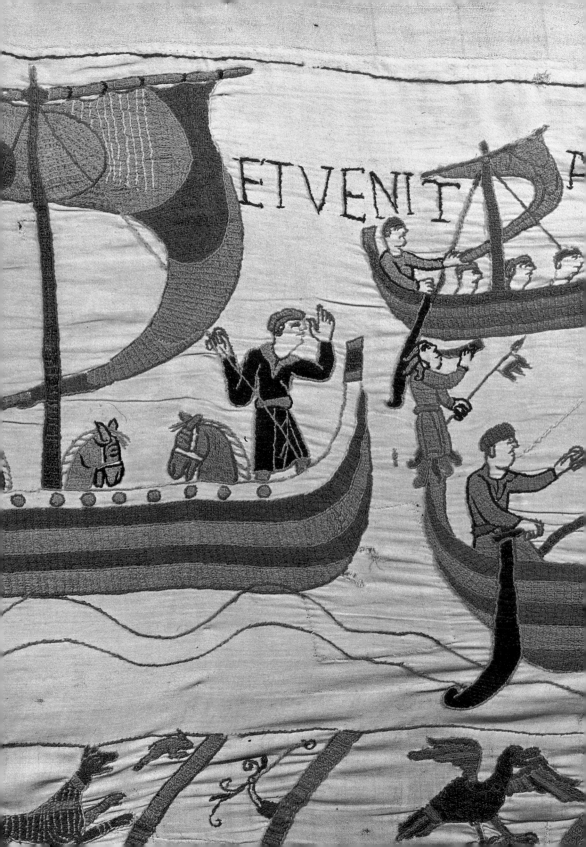

ET VENIT

Introduction

Why paint a ship? Many artists have included boats and ships in their work, either as incidental local color or as part of the narrative. But there is a whole genre of painting in which the ship is the principal subject. Such works are often regarded as specialist, for the enthusiast only. Nevertheless, it would be wrong to dismiss this genre as "difficult" by placing it outside the mainstream of art. Landscapes, portraits, mythological, and history paintings, despite their greater familiarity and perhaps more instant appeal, also require some knowledge or study of their social and historical context if they are to be appreciated fully.

It is true that the interest of a ship painting is not usually self-evident. To the uninitiated, paintings of ships from the seventeenth through to the nineteenth century can look very similar. They depict objects, one might almost say machines, which are no longer familiar to us. Most people have seen large sailing yachts at sea, but none of us has seen a seventeenth-century warship in full sail, and none of us will ever find ourselves in the middle of a great sea battle surrounded by such ships.

The material and political importance of ships and the sea to many of the nation and city states of Europe during the past five hundred years is easily overlooked today. Control of the sea could be a vital element in the survival of a nation, upon which its security, trade, and livelihood were dependent. The ship was the tangible symbol of all this, and as such became a worthy subject for the artist, and indeed his patrons. Pictures of ships came to be required by all kinds of people, but especially by those who were directly involved with the sea, for whom they often had a very specific meaning.

A simple definition of the term "ship" in this book may be helpful. It is used in a broad, non-technical way to describe large sea-going vessels, usually capable of traveling long distances with men living on board. Excluded, therefore, are the more intimate coastal activities involving small craft also much painted by "marine artists", a term which may again require definition. It has traditionally been used to describe artists who specialized in painting ships and small craft, but, of course, also the sea and coasts. In the nineteenth century it came to be used more generally for painters of coastal landscape, such as Boudin, who were more closely allied with landscape painting.

It would, however, be misleading to suggest that ships have been painted only by marine artists. Clearly the ship has provided subjects for a much wider range of artists, from the time of the Italian Renaissance to the English and French artists of the Romantic movement and right up to the present day.

1 **Bayeux Tapestry (detail), late 11th century**
Woolen thread embroidered on linen, approx. 587 × 50 cm
Bayeux, Calvados

In this detail duke William's fleet is depicted sailing to Pevensey in their typically northern single-masted craft with square sails, very like the Viking vessels from which they originated. They are propelled mainly by sails rather than by oars—there are no oar-ports. Some of the vessels carry horses in preparation for the landing.

The ship as a subject in its own right

The depiction of ships in a variety of media extends far back into antiquity. Very detailed depictions appear, for example, as part of the decoration on Greek vases. In more recent times, that is from the twelfth century onwards, the motif of the ship has been used in the design of town seals. Medieval seals are of great documentary value because they usually show ships of the period, providing the best available evidence of early ship types. Often, too, men are shown at work on these vessels indicating the way in which they were sailed. The Bayeux tapestry, dating from the eleventh century, contains very good representations of the ships of William the Conqueror and the Anglo-Saxons. Following on from this the majority of the earliest illustrations of ships appear in manuscripts. More substantial images, in paintings, do not become common at all until the fifteenth century.

Specialist ship painters emerge for the first time in the Netherlands about 1600, but their appearance had been anticipated by some extremely accurate representations of ships in the fifteenth and sixteenth centuries in both northern and southern Europe. These early artists, especially when living in a great maritime city such as Venice, were able to create some beautiful depictions of ships, but they were typical rather than specific, named vessels, and no more than an incidental component in the composition, included to illustrate the story being told. This is certainly the case in Pinturicchio's fresco *Scenes from the Odyssey* (2). This shows in the background, framed as if by a window, and so almost a complete marine painting on its own, a large sailing ship. The artist has made no attempt to repre-

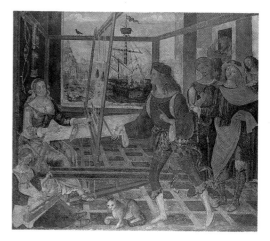

2 Pinturicchio
Scenes from the Odyssey, c1500
Fresco transferred to canvas, 126 × 152 cm
London, National Gallery

The artist presents a somewhat misunderstood version of the story of Ulysses. But he includes beyond the main activity in the foreground a large carrack which was the larger type of trading vessel in use from the 14th to the 17th century, the forerunner of the three-masted ships which were to become the common type in Europe right up to the 19th century and the introduction of steam. This example appears to have four masts, although the foremast is concealed. The bulwarks are decorated with heraldic shields, depicting the arms of the Petrucci family from whose palace in Siena the picture came, and those of the city of Genoa.

Detail of 2

sent a ship of classical antiquity, but instead shows a large carrack of the early sixteenth century, the sort of large trading ship used in both northern and southern Europe at the time, and the type of vessel most commonly shown in Renaissance pictures.

Sometimes the ship was central to the story being told, for instance in the legend of St. Nicholas, a patron saint of seafarers. In *St. Nicholas rebuking the tempest* (**3**), part of an altarpiece painted by Bicci di Lorenzo in the 1430s for the Florentine church of San Niccolò in Cafaggio, all the action and narrative are focussed upon the stricken ship. A simile of the sick soul rescued from sin by divine grace, a panel like this foreshadows a favorite motif of seventeenth-century Dutch marine painting, that of the ship in distress, both in its composition and in its spiritual message.

Another story in which voyage by ship featured was the legend of St. Ursula. Both Hans Memling working in Bruges and Vittore Carpaccio at Venice took the opportunity to include ships in their versions (**4**, **5**), both painted towards the end of the fifteenth century. The reliquary of St. Ursula painted by Memling, shaped in the form of a miniature Gothic chapel, has many depictions of the kinds of ships with which he must have been familiar. Similarly, Carpaccio's cycle of paintings for the Scuola di Sant'Orsola in Venice is a reflection of Venice and its life at the time, including the ships which were all-important to the republic's prosperity and survival. Carpaccio's are perhaps the most authentic early Renaissance paintings of ships, but the artist gives them no more prominence than the streets and buildings or the figures who inhabit them.

The exact episode from the legend of St. Mark depicted in the badly damaged painting called *La burrasca* (*The storm*, Venice, Ospedale Civile), in another Venetian Scuola or pious

3 Bicci di Lorenzo
St. Nicholas rebuking the tempest, c1433
Oil on panel, 28 × 59 cm
Oxford, Ashmolean Museum

The vessel shown here, tossed by the storm, is a Mediterranean cog, a type of trading ship used in Europe and more commonly in the north at the time. She is "clinker built" (built of overlapping planks), is "broad in the beam", and has fore and aft castles.

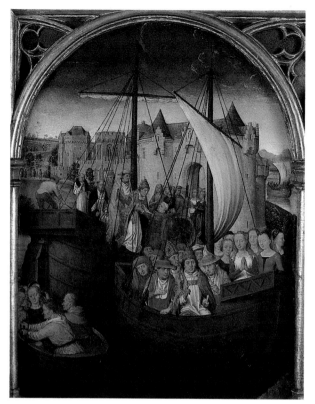

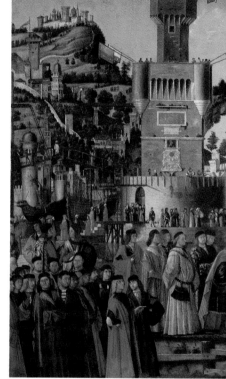

4 Hans Memling
The St. Ursula Shrine, left panel, 1479
Oil on panel, 37 × 25 cm
Bruges, Hôpital St. Jean

5 Vittore Carpaccio
The meeting of St. Ursula with her husband,
1500
Tempera on canvas, 280 × 611 cm
Venice, Accademia

Carpaccio painted some of the most authentic depictions of ships of his time. Their inclusion is, of course, vital to the story of St. Ursula, but the artist simply shows the ships which he saw every day in Venice, and upon which the state was so dependent. In this detail it is possible to see the "ratline", the rope steps used by men working aloft to climb up the mast.

Detail of 5

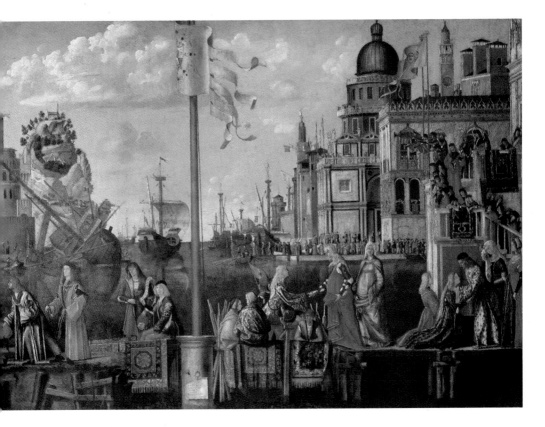

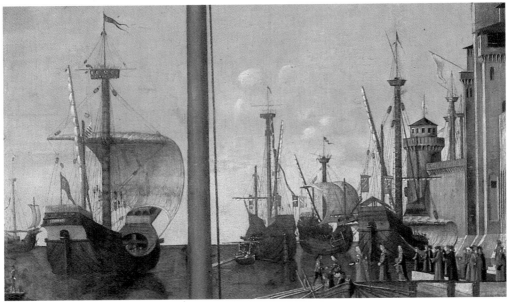

13

confraternity, the Scuola di San Marco, is not known, but it shows another maritime intervention, this time by St. Mark, the city's patron saint. Giorgio Vasari, the artist and biographer of many Renaissance artists, was so impressed by it that he supposed it was by Giorgione, though he later attributed it to Palma il Vecchio. "There may be seen counterfeited by Palma a terrible tempest on the sea, and some barques tossed and shaken by the winds, all executed with much judgement and thoughtful care. The same may be said of ... the demons in various forms who are blowing, after the manner of winds, against the barques ... I, for my part, do not remember to have ever seen a more terrible painting." His words convey something of the awe in which the power of the elements unleashed against human frailty was held.

One of the most important of all early paintings of shipping was painted at about the same time as *La burrasca*, that is about 1530, but its significance is very different. The painting has become known as *Portuguese carracks off a rocky coast* (**6**), and was possibly painted by the Amsterdam artist Cornelis Anthonisz, who is also known as a cartographer and navigator. Its importance lies in the concentration of interest in the group of shipping which occupies the center of the picture, where the artist depicted, or portrayed, particular vessels. It is now thought that the central ship is the *Santa Catarina de Monte Sinai*, a large Portuguese carrack which had been built of teak at Cochin in India, and that the picture illustrates the voyage in 1521 of the Infanta Beatriz from Portugal to Villefranche to marry the duke of Savoy. The picture is therefore one of the earliest of all ship "portraits", meaning an accurate representation of a particular ship.

It is possible the artist never actually saw these ships; he may have used verbal descrip-

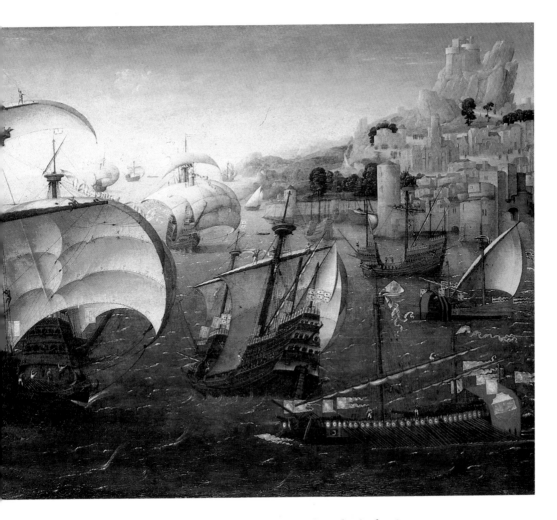

6 Cornelis Anthonisz
Portuguese carracks off a rocky coast, c1530
Oil on panel, 78.5 × 145 cm
Greenwich, National Maritime Museum

It is thought that this very early marine
painting may show the carrack *Santa Caterina
de Monte Sinai* bringing the Infanta Beatriz of
Portugal to Savoy for her marriage to Charles
III, duke of Savoy, in 1521. Such large armed
merchant vessels were used on trading routes
to the East Indies, and indeed, the *Santa
Caterina* was actually built in India (of teak) at
Cochin.

tions and drawings or engravings to enable him to represent the shipping. This would explain why, although all the ships sail on the same sea, the wind which propels them appears to come from different directions, something which might easily have resulted from the use of a variety of sources. Pictures like this repay close scrutiny for the wealth of detail they contain, relating not only to the construction of the ships, but also to the men who sailed them, for example the figures in the rigging in this picture. The same artist, Cornelis Anthonisz, has also been associated with the painting in the British Royal Collection which shows king Henry VIII embarking at Dover on his way to France for his historic meeting with king Francis I at the Field of the Cloth of Gold in 1520. Like *Portuguese carracks* it contains portraits of some of the ships which were part of Henry's navy.

Pictures such as these, whether they are by

7 **Pieter Bruegel**
The fall of Icarus
Oil on canvas, 74 × 61 cm
Brussels, Musées Royaux des Beaux-Arts de Belgique

In illustrating this story, taken from Ovid's *Metamorphoses*, Bruegel has chosen to include a ship, a large, four-masted carrack of the mid-16th century. It shows the stage of development of the carrack at this time, and, in particular, the more sophisticated rigging in which men are at work. Bruegel's interest in shipping was more than incidental, and he was one of the first artists to deliberately make drawings of ship types—those that he would have seen around him on the coast of northern Europe.

Detail of 7

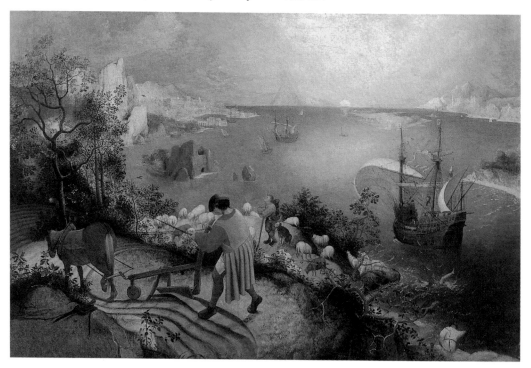

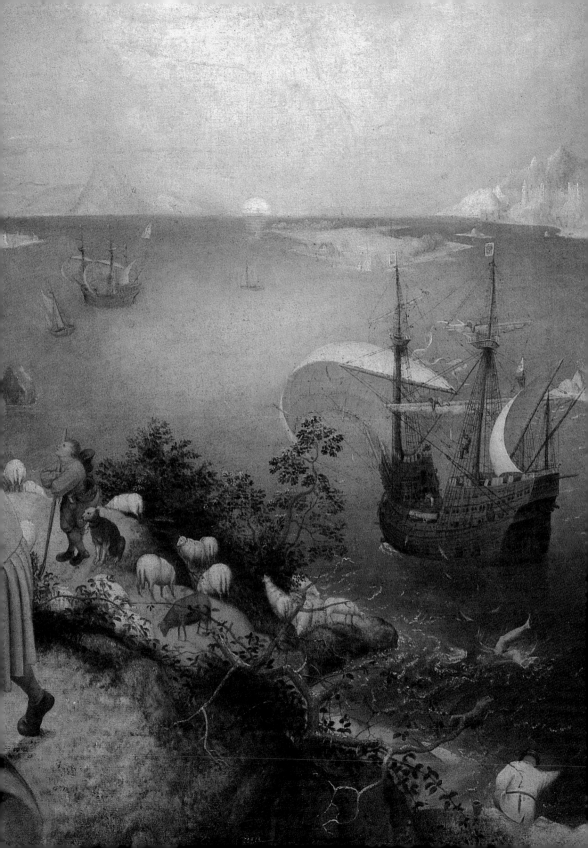

Anthonisz or another north European artist, pre-date the revolutionary marine paintings of Pieter Bruegel the Elder, who worked in Antwerp and Brussels. Although Bruegel is best known for his pictures of peasant life, he had a deep interest in the sea and ships and developed an authoritative knowledge of them. Toward the end of his life, during the 1560s, he produced designs for a series of eleven prints which are detailed depictions of a range of vessels of different sizes and can be regarded as ship portraits. In his famous *Fall of Icarus* (**7**), depicting the mythological Icarus falling into the sea after melting the wax of his artificial wings by flying too close to the sun, Bruegel shows only the feet and legs of Icarus as he plunges head first into the sea, while a dominant feature is a large ship nearby, a contemporary four-masted carrack. Here Bruegel's concern is not solely with the ship, but the clouds, the sea, the peasant working in the fields all contribute to the picture. However, in the *Storm at sea* (**8**), formerly attributed to Bruegel, the struggle of about fifteen ships on a stormy sea, the peril of ships and men, is the whole subject. Paintings of tempest and shipwreck were to be developed by the Dutch and Flemish marine painters of the following century, and the subject became a genre in its own right.

8 Attributed to Joos de Momper (formerly Pieter Bruegel)
Storm at sea, c1568
Oil on panel, 70 × 96 cm
Vienna, Kunsthistorisches Museum
Possibly the earliest depiction of a group of ships (perhaps as many as fifteen) in a tempest, it includes the allegory of a barrel thrown overboard to distract the forces of evil, represented by the whale.

Great battles and other occasions

Toward the end of the sixteenth century there occur the first paintings which depict ships engaged in battle at sea, an aspect of marine painting which was to become the most important subject for the marine painter until well into the nineteenth century, and even to the present day. There are several representations of the vital Christian victory at the battle of Lepanto off the coast of Greece on 7 October 1571, between the combined fleets of the members of the Holy League and the Turkish fleet of the Ottoman empire. One (9) may be by the Haarlem artist Hendrik Cornelisz Vroom, who with some accuracy has been referred to as "the father of marine painting".

It was this artist who, through the depiction of battles at sea, brought the painting of ships into prominence in the closing years of the sixteenth century. As early as 1590 Vroom made designs for the English naval commander Charles Howard of another important maritime conflict of the period, in which Philip II of Spain sent a great "armada" to invade England. The designs were for a series of tapestries rather than paintings, but the commission demonstrates the usual pattern of patronage for a marine artist over the following centuries. Howard had commanded the English fleet which defeated Philip's Armada, and the tapestries which were made from Vroom's designs commemorated and recorded in detail the actions of the English fleet under their owner's command.

The ships which appear in Vroom's tapestry designs are seen from a high "bird's eye" viewpoint, which links the early origins of marine painting with cartography. This kind of viewpoint persisted into the early

9 Inscribed H. Letter (possibly Hendrik Cornelisz Vroom)
The battle of Lepanto, 7 October 1571, late 16th century
Oil on canvas, 127 × 232.5 cm
Greenwich, National Maritime Museum

Following the proclamation by Pope Pius V of the Holy League with Venice, Spain and other allies to check the expansion of the Ottoman Empire, over two hundred galleys under the command of Don Juan of Austria attacked the slightly larger Turkish fleet about forty miles from its base at Lepanto on the western coast of Greece. It was the last sea battle on such a scale to be fought between galleys propelled by oarsmen.

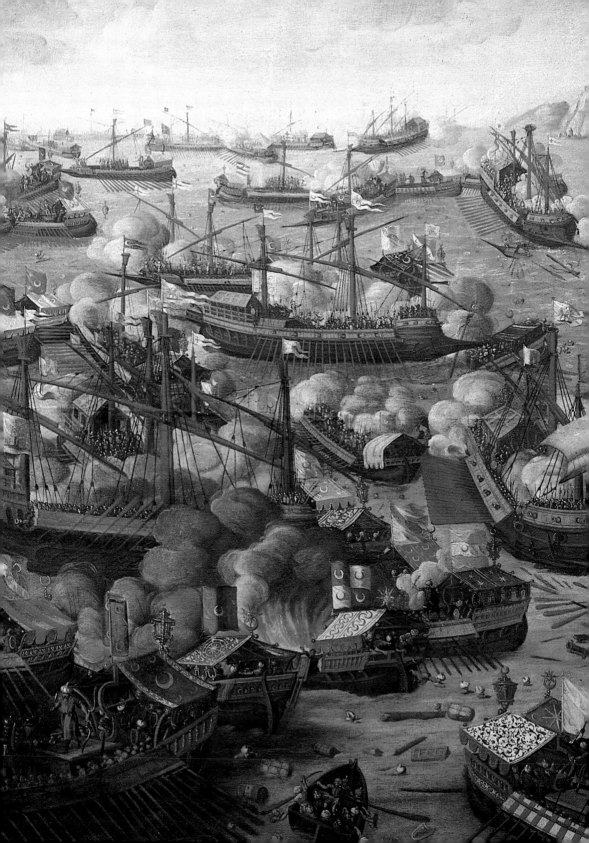

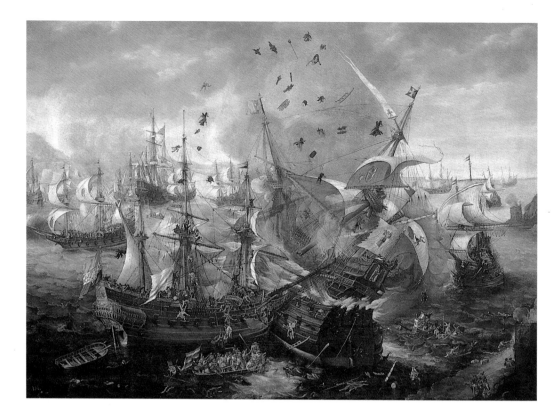

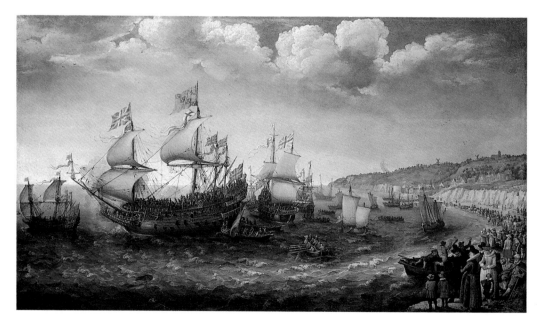

10 Attributed to Cornelis Claesz van Wieringen

The battle of Gibraltar, 25 April 1607, 1607

Oil on canvas, 137.5 × 188 cm
Amsterdam, Rijksmuseum

Now considered to be by Vroom's pupil Cornelis Claesz van Wieringen, this picture of ships in spectacularly close combat uses the high viewpoint derived from the map makers. Like many pictures by the first specialist ship painters in the early years of the 17th century it illustrates the continuing struggle by the Dutch for independence from Spain.

11 Adam Willaerts

Embarkation of the Elector Palatine in the Prince Royal *at Margate, 25 April 1613*, 1623

Oil on panel, 77.5 × 137 cm
Greenwich, National Maritime Museum

This painting of the departure of James I's daughter from England following her marriage to Frederick V contains a remarkable depiction of the king's most important ship, the *Prince Royal*, built by Phineas Pett and launched in 1610, the first three-deck ship in the English Navy. She was named in honor of the king's son, Prince Henry, who regarded her as his own and with whose badges she was elaborately decorated. It was for the prince that the miniature ship, the *Disdain*, visible on the extreme left, was also built. As part of the lavish marriage celebrations the couple had witnessed a mock sea fight staged on the river Thames.

seventeenth-century panoramic views of sea battles and may be seen in *The battle of Gibraltar* (**10**), formerly thought to be by Hendrik Vroom, but now considered to be by his pupil Cornelis Claesz van Wieringen. Like many other ship paintings of this period the subject is linked with the struggle of the Northern Provinces for independence from Spain, which once achieved was to open the way to the prosperity depicted in so much Dutch art of the seventeenth century, including the marine paintings.

This wonderfully detailed picture, gleefully showing all the terrible detail of the battle as the Spanish ship blows up, throwing men high into the air, demonstrates the degree of accuracy which had already come to be expected of the marine painter, not only in the construction of ships but also in the way they were placed in the water in relation to the enemy at a given moment. However, the subjects are shown in local coloring, unchanged by the prevailing effects of atmosphere, which artists do not at this period attempt to portray.

Ships taking part in state occasions, frequently with royalty, also provided subjects for commissions to marine artists. Hendrik Vroom painted such occasions, as did the Utrecht artist Adam Willaerts. His picture of the departure of the Elector Palatine from England following his marriage to James I's daughter Princess Elizabeth in 1613 (**12**) was painted some ten years after the event for political reasons: the Elector had since been deposed as a result of the early Hapsburg successes in the Thirty Years War, and was appealing to his brother-in-law Charles I for help. (Hendrik Vroom and Cornelis Claesz van Wieringen also painted versions of the subject at this time). Willaerts staffs his picture with figures dressed according to the fashions of the Netherlands, but the ships are accurate

portraits of English ships of the period. As in Vroom's paintings, the viewpoint is high and the bright color is local with no attempt to reproduce the atmospheric conditions of the English Channel.

During the 1620s Dutch ship painters began to be more interested in observing and depicting nature to a greater degree of realism. The high viewpoint gradually gives way to a lower one, and the coloring is increasingly atmospheric, almost monochrome. This we can see in Porcellis's *Dutch ships in a gale* (**12**). But the viewer should not be led to believe that realism was the whole concern of the artist. When looking at these pictures it is important to be aware of the symbolic content present in most forms of Dutch creative art during the seventeenth century. Marine painting was dominated by a concept of the sea as a place of passage, just as life is a place of

12 Jan Porcellis
Dutch ships in a gale, c1620
Oil on panel, 26.5 × 35.5 cm
Greenwich, National Maritime Museum

This little picture epitomizes the symbolic marine paintings of the early 17th century. The artist strives to portray the effects of nature realistically, in this case a wild stormy sea, in order to convey the message of the picture. This would have been understood by its first owner, just as, for example, a still life containing a realistically painted skull or hour glass would have had a quite particular meaning. The ship, therefore, is an accurate depiction of a type of vessel but not of a particular ship.

Detail of 12

24

passage for the human soul. All the components of marine paintings, such as rocks, monsters, patches of clear sky came to have a contributory significance which it is difficult to convey today. As a means of understanding what Porcellis's picture might have suggested to its original owner, one scholar has used the example of an eighth-century hymn:

Tossed on the sea of life
 and sick and sore distressed,
I lift my cry to Thee, O Lord,
 Who givest the Troubled rest.
There, where the waters yawn,
 and cruel monsters grin,
My comrades sink to depths below,
All in a sea of sin.

To emphasize the underlying message of the painting it is worth noting that the ship as well as the place are anonymous and that the realistic depiction of the sea and sky are used to bring home the point. "Porcellis does not creep into the forecastle, but considers the storm calmly (in spite of water, rain, hail and thunder), in order to examine in life this raging element, (an example) which you engrave in (your) thoughts." When seventeenth-century artists included a marine painting in the background of their pictures, it might often hold a key to the meaning of the picture, a calm seascape or a stormy sea insinuating quite different interpretations.

In Vermeer's *The letter* (Rijksmuseum) the woman, holding a letter from her lover, and her maid exchange a glance. We do not know the precise meaning of this, but the turbulent seascape behind them, though not a storm or shipwreck, is clearly intended to provide a clue. More explicitly in Gabriel Metsu's *Woman reading a letter* (Blessington, Sir Alfred Beit Collection) the maid draws a curtain to reveal a ship in a tempestuous sea.

The Dutch were clearly masters of the genre of marine painting at this period, though they often worked for English patrons as well as Dutch. As we have seen, Hendrick Vroom certainly had contact with English patrons well before 1600 and Dutch pictures of shipping had entered the Royal Collection (notably in the form of the "Dutch Gift" of 1610 which included a pair of paintings by Vroom). There was, however, no resident painter of ships living in England until after 1650. But an early portrait by Sir Peter Lely is remarkable for the inclusion of a ship—which is included because of her importance. The portrait of the shipwright Peter Pett (**13**) shows prominent in the background the largest and most important ship ever built in England, the *Sovereign of the Seas* (1637). She is shown from the stern to show off her richly carved and gilded decoration, executed by the same craftsmen who carved the decoration in Henrietta Maria's house at Greenwich in the early 1630s, and it is likely that the artist who painted this part of the picture was Dutch, possibly Isaac Sailmaker.

When war broke out between the Dutch and the English, in the 1650s, again in the 1660s, and finally in the early 1670s, marine artists working in Holland once again recorded their battles at sea. Since Vroom and Porcellis there had been considerable progress in marine painting. In the hands of some artists, painters such as Van Goyen and Van de Cappelle who depicted coasts, estuaries and beach scenes, it closely resembled landscape painting, while other artists remained specialist painters of ships. Others again combined the two trends to create some of the most sophisticated images of ships in Western art—ships carefully observed and understood, placed in an equally well-composed setting of sea and sky. These artists belong to the so-called "Golden Age" of Dutch painting.

The artists who recorded the sea battles of

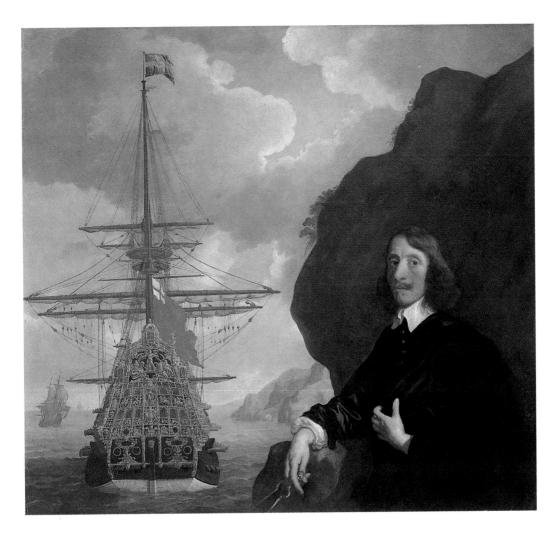

13 Sir Peter Lely
Portrait of Peter Pett and the *Sovereign of the Seas*, 1637/8
Oil on canvas, 139.5 × 156 cm
Greenwich, National Maritime Museum

The most powerful ship in the English navy, the *Sovereign of the Seas* mounted 100 guns, and in broad terms was the model for first-rate ships until the ironclads in the 19th century. She was built for Charles I at Woolwich by Peter Pett under the supervision of his father Phineas and launched in 1637. She was later rebuilt and renamed *Royal Sovereign* in 1660, rebuilt again in 1685, and accidentally burned in 1696. The picture shows off the elaborate stern carvings by John and Matthias Christmas to designs possibly by Thomas Heywood: the king had specified that the only colors to be used were black and gilt.

these wars were working usually for the seamen who took part or the government. Naturally they dwelt on their successes. Ludolf Bakhuizen's painting, *The* Royal Charles *carried into Dutch waters* (**14**), is an image of conquest. The ship bearing the name of the English king was captured during a daring attack on the English coast by the Dutch. She is shown arriving off the Dutch coast, silhouetted against a slanting light in such a way as to lend pathos to the occasion.

The two Dutch artists who were the most effective and versatile in the depiction of ships were the Van de Veldes, father and son, both called Willem, usually referred to as the Elder and the Younger. They were, not least, the best organized of marine artists, who were able to tackle any commission with the help of the store of portrait drawings of ships which they were constantly augmenting. Willem the Elder was the expert draughtsman, while in due course Willem the Younger developed as a painter who could use his father's drawings to construct whatever subject was required by his patron. This is the essence of their known practice, although it is something of a simplification.

Working in the first place for the Dutch government Willem the Elder traveled extensively with the fleet, sometimes as far as Scandinavia, making drawings both of Dutch ships and of foreign or enemy ships as well as the ports and coastlines encountered. While on these duties Van de Velde traveled in his own small sailing craft, a galliot, and in 1653, during the first Dutch War, he was actually present in the thick of the battle of Scheveningen making drawings of the ships and the progress of the battle. (In the resulting paintings, drawings or grisailles he often included himself drawing in his galliot.) However, in the middle of the third Dutch War, during the winter of 1672–73, the unstable political

14 Ludolf Bakhuizen
The **Royal Charles** *carried into Dutch waters*, **1667**
Oil on canvas, 122 × 198 cm
Greenwich, National Maritime Museum

In June 1667 during the second war between the English and the Dutch, the Dutch carried out a daring raid up the river Medway, and captured the *Royal Charles* at Chatham, a humiliation for the English. Bakhuizen depicts the English ship, named after the king himself, brought back to Holland in triumph— presumably as a commission for a Dutchman involved in the raid. The English royal arms from the stern of the ship, clearly visible in the picture, may now be seen in the Rijksmuseum in Amsterdam. Built at Woolwich dockyard during the Commonwealth period as the *Naseby*, the 80-gun ship was renamed on the restoration of king Charles II in 1660.

Detail of 14

situation in Holland caused the Van de Veldes to emigrate to London, where they worked for king Charles II and his brother James duke of York, then Lord High Admiral (he became king James II in 1685). Having in 1672 observed the battle of Solebay on behalf of the Dutch authorities, the Van de Veldes now set out to portray the same events from the English angle. The king paid them each one hundred pounds, the duties of father and son being quite specific: the Elder "making Draughts [ie drawings] of seafights", the Younger "putting the said Draughts into Colours for our particular use" (paintings). Like Vroom's, nearly one hundred years before, their first commission was for cartoons of tapestries depicting the battle of Solebay, made in the form of large paintings.

In 1674 the Elder Van de Velde mentioned that he "had never done anything for anybody other than His Majesty and for the Duke of York, and that kept him totally occupied." The duke provided the artist with a ketch from which he was able to witness and draw the first and second battles of Schooneveld in May and June 1672, enabling him to operate just as he had been used to previously in Holland. In the following year, however, the duke, anxious for Van de Velde's life, forbade him to witness the battle of the Texel, so that his subsequent pictures of the battle were not from first hand but based on information supplied afterwards. Perhaps in the flamboyant portrait of the duke painted by the French artist Henri Gascard in 1672–73, soon after their arrival, we may see tangible evidence of the duke's esteem for Willem the Younger: dressed as Mars and surrounded by the instruments of war, the duke stands in front of a background of shipping based on a now lost painting by Van de Velde. The event depicted is a royal visit to the fleet, when a council of war was held on board James's flagship the

Prince Royal.

However, the painting which we now consider to be Van de Velde the Younger's *tour de force* was painted in 1687 just before James II fled from England to France. Perhaps Van de Velde was once again testing out the Dutch market, for it seems possible that his great *Battle of the Texel* (**15**) was painted for Cornelis van Tromp, whose flagship the *Gouden Leeuw* can be seen in the center of the picture, her white gunsmoke billowing over the steel-gray sea. The battle had taken place in 1673, but such a commission would have provided no difficulties for Willem the Younger, with the collection of drawings at his disposal.

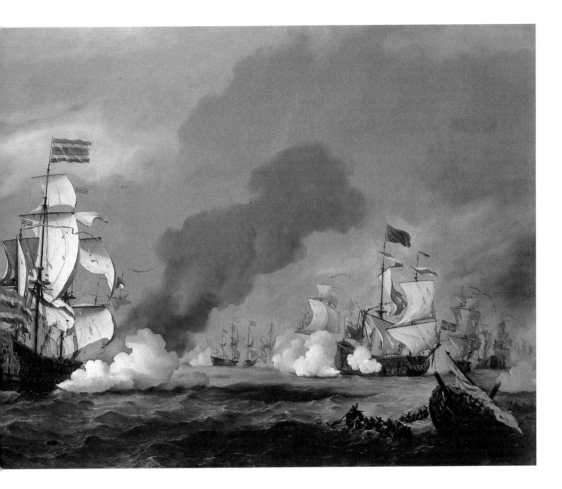

15 Willem van de Velde the Younger
The battle of the Texel, 11–21 August 1673, 1687

Oil on canvas, 150 × 299.5 cm
Greenwich, National Maritime Museum

This painting of the last battle of the third Anglo-Dutch War was painted in 1687 fourteen years after the event, clearly for a Dutchman. Because the most prominent ship in the center of the picture is the *Gouden Leeuw* (Golden Lion), the ship of Lieut-Admiral Cornelis van Tromp. Having painted for English patrons since 1672–73, Van de Velde here reverts to depicting events from the Dutch angle. The *Gouden Leeuw* fires guns to port at the *Charles*, and starboard where, on the right, the *Prince* (blue flag) may be seen, attempting to tack, an operation to bring the wind on the opposite side of the vessel. It is this operation which tells us the precise point in the battle, for Narborough, present at the battle recounts: "The wind being Good at:SW: and a fine fresh gale Our Admiral of the Blew, made way to stay, When the shipp, cam in the wind with her head sailes she fell off again & would not stay.... When the wind was on the Beame, the Maine mast, fell by the Board at once ... Presently this was about one of the Clock in the Afternoone."

Requirements of the specialist marine painter

Paintings like this, as they continued to be produced by the Van de Velde studio into the eighteenth century, became the stock-in-trade of following generations with little attempt at innovation. Peter Monamy (1681–1749), Samuel Scott (1701/2–72) and others continued to paint for those who wanted their ships and battles commemorated, but although artists updated the design of the ships, there was little attempt to advance upon what the Van de Veldes had achieved; indeed, the opposite was the case.

It is not only specially trained marine artists who can provide us now with informative images of shipping, but also those from different backgrounds. Thomas Phillips worked as a military draughtsman drawing fortifications along the coasts of the British Isles. His *Section through a first rate ship*, a large warship of the 1680s (16), tells us how the ships we see in the Van de Veldes' paintings were arranged internally. It has to offer some fascinating and surprising details—for example that the captain's cabin is hung with marine paintings set into the paneling, quite possibly by the Van de Veldes, whom Phillips must have known.

16 Thomas Phillips
Section through a first-rate ship, 1690?
Oil on canvas, 56 × 148.5 cm
Greenwich, National Maritime Museum

Although Phillips' main activity was as a military engineer, he was also familiar with ships, and in 1661 he was appointed by the duke of York as master gunner of the *Portsmouth*. He therefore had the interest and knowledge to enable him to produce this cut-through section of an important ship, although we do not know what its original purpose was. It may be connected with the new gun carriage which Phillips invented in 1690, and with which all the guns of the *Royal Sovereign* were ordered to be supplied.

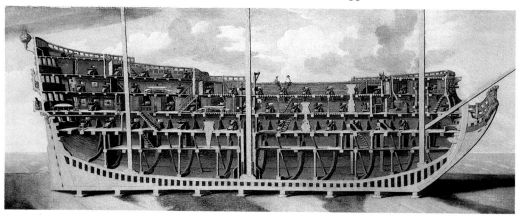

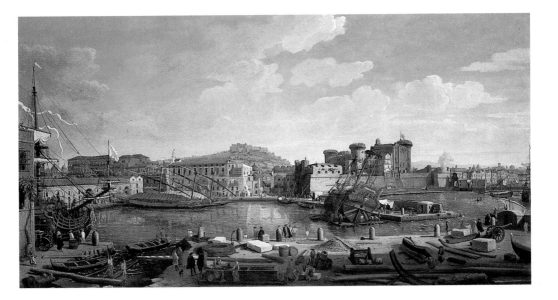

17 Gaspar Adriaansz van Wittel
The Castello Nuovo at Naples, 1703
Oil on canvas, 76 × 139.5 cm
Greenwich, National Maritime Museum

It would be wrong to assume that only marine painters can paint ships accurately or informatively. Here in a view of a southern port, full of brilliant color, a Dutch landscape painter working in Italy includes among other shipping the detail of a ship careened, that is, tilted onto its side while men work on the hull.

Similarly one might not expect to learn anything of nautical significance from the work of a Dutch landscape painter working in Italy, and yet in Van Wittel's lively view of the Castello Nuovo at Naples (**17**), we see in the foreground a Neapolitan merchant ship being "careened", that is, tilted over onto her side while men working on a pontoon clean her hull.

The overseas colonial wars of the eighteenth century, including the American War of Independence, provided a climate in which marine painters flourished in England, not only in direct relation to overseas naval operations, but also to trade, another aspect of Britain's expanding sea power.

Writing of the arts in England in the middle of the eighteenth century the Frenchman Rouquet observed, "Everything that relates to navigation is so well known in England, and so interesting to that nation, that it is not at all surprising to see them greatly pleased with marine pictures." He also remarks that, "When one or two hands become as eminent, as those who are now distinguished for marine pic-

tures in England, are not they capable of giving a character of superiority to their country."

Although France was also a maritime nation, with a long coastline bordering the Atlantic, and the Mediterranean, with major naval dockyards at Brest and Toulon, and overseas colonies in the West and East Indies, there were not so many specialist marine artists there as in England. There were certainly painters of shipwrecks and storms but their work is more closely related to landscape than anything the English produced. Joseph Vernet, however, known for his pictures of shipwrecks, painted a famous series of dockyard views for king Louis XV, which are full of ships and nautical activity of all kinds (**18**). Furthermore, Dominic Serres, a Frenchman born in Auch in Gascony, who was captured as a prisoner of war by a British frigate from a vessel he commanded trading to Havana, in time became the leading painter of ships and the sea in England, a founder member of the Royal Academy of Art in London, later its Librarian, and eventually Marine Painter to king George III.

During his early years in England, Serres would certainly have been aware of two important marine artists, who are very likely the "two hands" mentioned by Rouquet, Samuel Scott and Charles Brooking. Brooking, above all others, breathed new life into the painting of ships and the sea in England before his untimely death in 1759. *Ships in a light breeze* (**19**) is an outstanding example, with ships, perfectly observed in all their detail, placed in the water in correct perspective and in harmony with all the elements, especially the wind which drives the ships and makes the small waves upon the sea. Brooking's work is characterized by this freshness of approach in which all elements of the picture work together. All is measured and understood as if

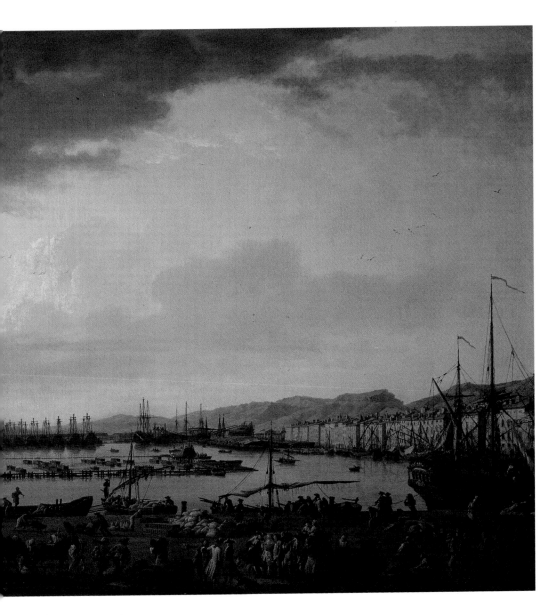

18 Claude Joseph Vernet
Third view of Toulon, 1756
Oil on canvas, 165 × 263 cm
Paris, Musée de la Marine

Commissioned by Louis XV's Minister of Works at the request of the king, Vernet's great series of paintings of the ports of France were intended to illustrate the maritime resources of France, including the fortifications and the ships. The picture contains considerable detail illustrating the life of a busy naval port, including a large ship, *l'Ocean*, being built.

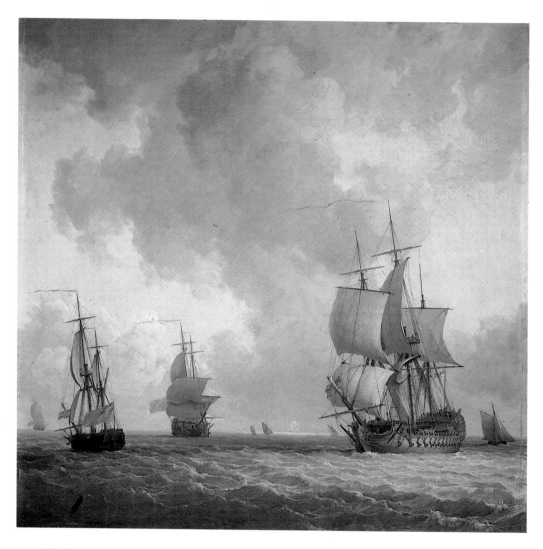

19 Charles Brooking
Ships in a light breeze, c1758
Oil on canvas, 68.5 × 68.5 cm
Greenwich, National Maritime Museum

No name is attached to the main vessel, but the picture is probably intended as a "ship portrait", that is an accurate depiction of a particular ship. In this case it shows a naval two-deck ship with 74 guns, probably of the "Dublin" class. These came into operation right at the end of the Brooking's life, making this a late work by him. The other ships are also accurately depicted, as are the conditions in which they sail: sea, wind, sky, and light. Brooking brings all these elements together in the elegant composition which has given his pictures universal appeal.

by a sailor, and painted with extreme sensitivity.

But what are the qualities that make a marine artist? The question was touched upon by John Thomas Serres (1759–1825), son of Dominic, in a discussion of marine draughtsmanship written in 1805–06, about the time of the battle of Trafalgar: "...a person desirous of excelling in this Art should possess a knowledge of the construction of a Ship, or what is denominated 'Naval Architecture' together with the proportion of masts and yards, the width, depth and cut of the sails, &c; but he should likewise be acquainted with Seamanship".

Whether Brooking, like Dominic Serres, went to sea is not known, but he undoubtedly had a sound knowledge of ships and their construction learned from his background in the Deptford dockyard on the river Thames, on the way into London, where many of the most important naval ships were built. Here too in Deptford the Cleveley family lived and worked. Originally trained as a shipwright, John Cleveley produced some of the most remarkable images of ships built at the dockyard. Ships are sometimes shown "on the stocks", that is during the course of being built, and surrounded by all the detail of timber and tools used by the shipwrights. Frequently the splendid spectacle of a ship being launched was chosen—often an occasion when a member of the royal family was present, as in Cleveley's HMS Royal George at Deptford (21). Although it lacks the poetry of Brooking, Cleveley's picture includes fascinating details, for instance musicians playing and punch bowls being handed around quite apart from the retinue of smaller craft.

None of the eighteenth-century marine painters is known to have painted the interior of a naval ship, showing the crew or even the officers at work. Such images were not generally created until the age of photography. But William Hogarth in his portrait of Lord George Graham (20) provides a rare glimpse of a naval captain on board his ship. Graham sits nonchalantly smoking his pipe, surrounded by his friends, while a servant brings a roast fowl to the table, the gravy spilling from the dish, and the central figure sings. The portrait may in some way commemorate a successful action in which he captured valuable Ostend privateers in 1745, but is more likely to have political overtones.

Instead of choosing to have his portrait painted by a fashionable artist Graham could have chosen to have the Ostend action painted by a marine artist. If so, would his demands of the artist have been as punctilious as Rouquet observes? "It is become almost the fashion for a sea officer, to draw the picture of the ship which he commanded in an engagement, and where he came off with glory; this is a flattering monument for which he pays with pleasure. The hero scrupulously directs the artist in every thing that relates to the situation of his vessel, as well in regard to those with whom, as to those against whom he fought. His politeness will not permit him to put any one out of his place; and this is a new point, of which the painter must take particular care. And indeed an error in arrangement, upon this occasion, might be taken as a very great incivility."

These were the kind of constraints under which the majority of marine painters worked, right up to the end of the Napoleonic Wars. An artist might be required to paint a series of paintings on the grand scale to commemorate a major offensive, such as the capture of Havana by the British in 1762, which Dominic Serres illustrated in a series of eleven paintings (22). Or an important battle might be the subject: Nicholas Pocock's Battle of the Nile, 1 August 1798 in Greenwich is a typical exam-

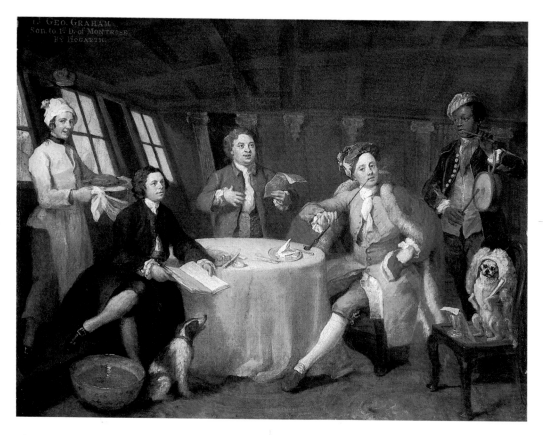

ple, its strict demarcation of the columns of English and French ships lined up for battle relieved only by the palm trees and the figures on the left. Another type of picture is the "frigate action", frequently painted for the commander of a vessel involved in a one-to-one skirmish with an enemy ship. The artist might be required to work from a verbal account, such as official dispatches, also perhaps a scribbled plan. Whatever the case, such commissions provided little challenge to the artist who painted them. For all the owner's satisfaction, one senses a degree of bewilderment in the wider audiences who first saw such pictures, for example those exhibited by Serres at the Royal Academy in the 1770s and 1780s. Their accuracy was acknowledged but with little enthusiasm: "... we even fancy ourselves anchored on the spot. The shipping are exceedingly correct and so far as one can judge from the accounts of the engagement, the manoeuvres are strictly represented. This performance ... never from beginning to end transported me in the least by its fire, vivacity or brilliant appearance; it is rather tame in all its parts...."

20 William Hogarth
Captain Lord George Graham (1715–1747) in his cabin, 1745
Oil on canvas, 68.5 × 89 cm
Greenwich, National Maritime Museum

Whatever the political or comic implications of this portrait (it certainly has many), it provides a glimpse of an 18th-century naval officer in the cabin of the ship of which he is the captain. We are probably here on board the *Nottingham*, and the picture may well have been painted in celebration of Graham's capture of several French privateers off Ostend in 1745.

21 John Cleveley
The Royal George *at Deptford showing the launch of the* Cambridge, 1757
Oil on canvas, 81.5 × 122 cm
Greenwich, National Maritime Museum

Painted the year after Vernet's *Third view of Toulon*, Cleveley's view of Deptford Dockyard is humbler in conception, but no less valuable for its detail, painted as it is by a former shipwright who would have worked on the ships being built there. The picture shows the celebrations in progress during the launch of an important naval ship. The building on the extreme left is the Master Shipwright's house. The *Royal George*, shown on the right, was a first-rate ship of 100 guns and had been launched at nearby Woolwich the previous year. She was one of the largest ships of her time and famous for capsizing at Spithead in August 1782 with the loss of about 900 lives, a tragedy commemorated in William Cowper's poem with the opening lines: "Toll for the brave, the brave that are no more."

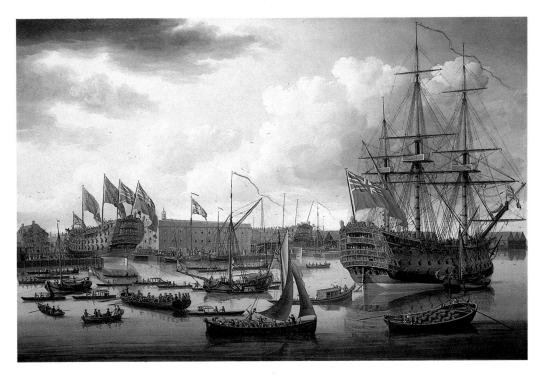

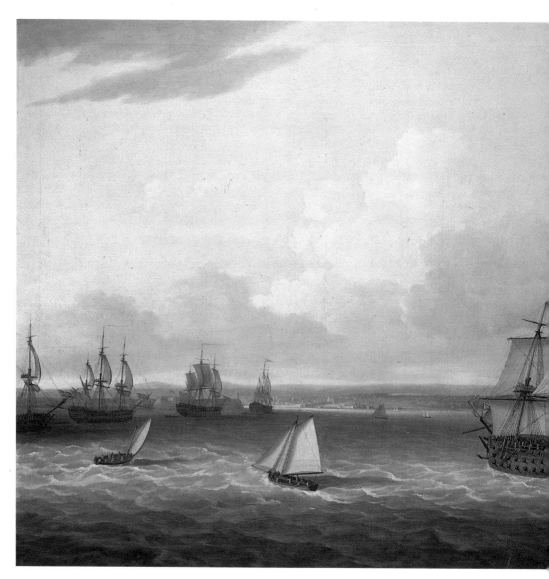

22 Dominic Serres
The British fleet entering Havana, 21 August
1762, 1775
Oil on canvas, 119.5 × 180.5 cm
Greenwich, National Maritime Museum

This is the last in Serres's series of pictures on the grand scale documenting the British expedition against Havana in 1762 commanded by the earl of Albemarle, for whom the series was painted. The capitulation was signed on 13 August 1762, and the British ships entered Havana harbor. On the left Augustus Keppel in the *Valiant* passes Morro Castle, while Sir George Pocock in the *Namur* approaches from the right.

Romanticism

While the marine painter was unable to rouse the public during the rise of what we now call the Romantic movement, the subject of ships and the sea began, by contrast, increasingly to be exploited by artists who, far from being bound by the small details of ship construction, saw the potential for much larger statements which made more of the human context and emphasized the drama of the moment. The first great sea battle of the wars between England and France in 1794, called the battle of the Glorious First of June, was painted by a range of artists, among them Nicholas Pocock, a former merchant ship commander who was actually present as an observer making drawings, and Robert Cleveley, the son of John; yet nothing these men produced matched the effect of the large, monumental painting of the battle painted by the French artist Philippe Jacques de Loutherbourg, who had arrived in London in 1771 (**23**). That de Loutherbourg worked as a theatrical scene painter is quite clear from the dramatic emphasis with which the subject is handled. He did not neglect the accurate depiction of the ships, for he made many drawings of HMS *Queen Charlotte* and others involved. But what he managed to convey—the enormous bulk of the ships, seen as great fighting machines, and the struggle of the sailors in the sea as the ships tower above them—is not to be found in any works of the marine painters of the eighteenth century, preoccupied with detail and correct arrangement.

De Loutherbourg's picture foreshadows developments in England and in France. The great mass and epic scale of men-of-war would soon fascinate Turner, and surely de Loutherbourg's stricken sailors seem to prophesy Géricault's contorted survivors on

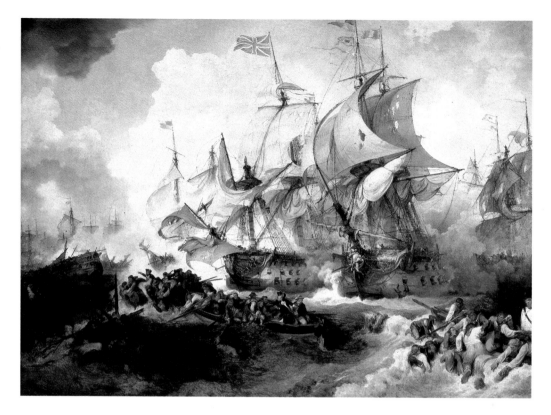

23 Philippe Jacques de Loutherbourg
The battle of the First of June 1794, 1795
Oil on canvas, 266.5 × 373.5 cm
Greenwich, National Maritime Museum

The opening battle of the long wars with
Revolutionary France provides two themes for
this Paris-trained artist. Firstly the grandeur of
the conflict between the two great war
machines locked in combat. On the left Lord
Howe's *Queen Charlotte* and on the right the
Montagne, the flagship of Admiral Villaret-
Joyeuse, show the effect of British fire as
bodies fall from the gunports. Secondly the
theme of compassion to the enemy fills the
foreground as British boats rescue the enemy
from the sea as they cling to the wreckage.

Detail of 23

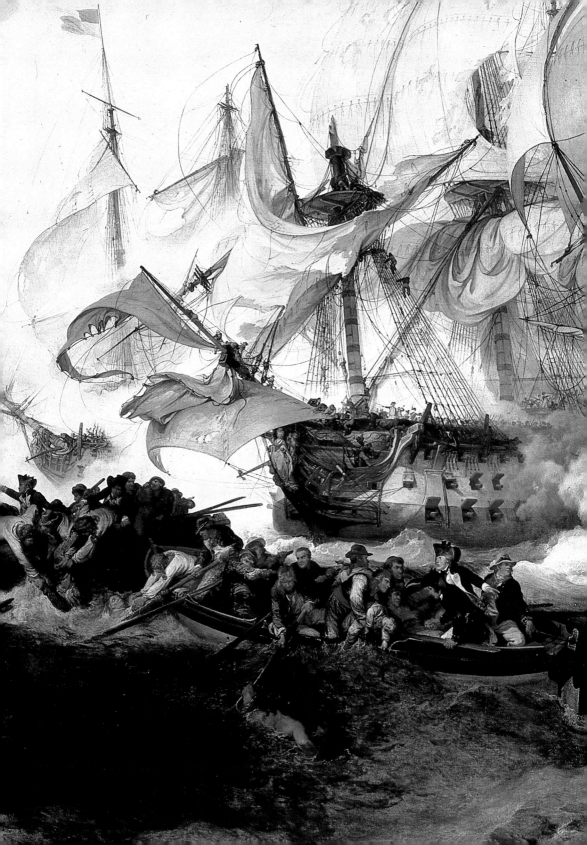

board *The raft of the Medusa* of 1819 (**24**). The sea and ships were of supreme importance to Turner, who produced some of his most memorable images on this theme. The story of Turner having himself tied to the mast in order to experience a storm at sea is well known.

There is a direct link between de Loutherbourg and Turner, since the *Battle of the First of June* was eventually acquired by the Prince Regent, who in 1823 as king George IV looked to Turner to paint a pendant to it (**25**). The subject was to be the battle of Trafalgar, which Turner had already painted, but not on this monumental scale. In attempting this major commission, the only painting by Turner to enter the British Royal Collection, and the largest he ever painted, Turner went to great pains to research his subject matter— he must have been acutely aware that among his audience was the king's brother, the duke of Clarence, then Lord High Admiral, a naval officer who had served at sea some time before the battle of Trafalgar and who was a patron of marine artists.

To represent HMS *Victory* correctly Turner wrote to John Christian Schetky, the marine artist who taught drawing to naval cadets at the Royal Naval College at Portsmouth, and Schetky responded with sketches of her

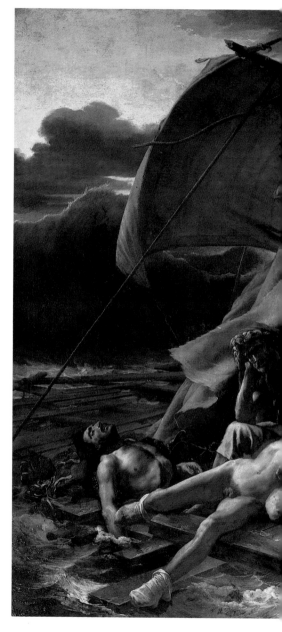

24 Théodore Géricault
The raft of the Medusa, 1819
Oil on canvas, 488 × 712.5 cm
Paris, Louvre

Géricault uses the sea as a setting for tragedy, taking as his subject the loss in mid-ocean of the French frigate *La Méduse* on her way to Senegal in 1816, when the raft containing one hundred and fifty survivors was deliberately cast adrift. When rescued two weeks later by the *Argus*, seen here on the horizon, only fifteen remained following horrific scenes including murder and cannibalism.

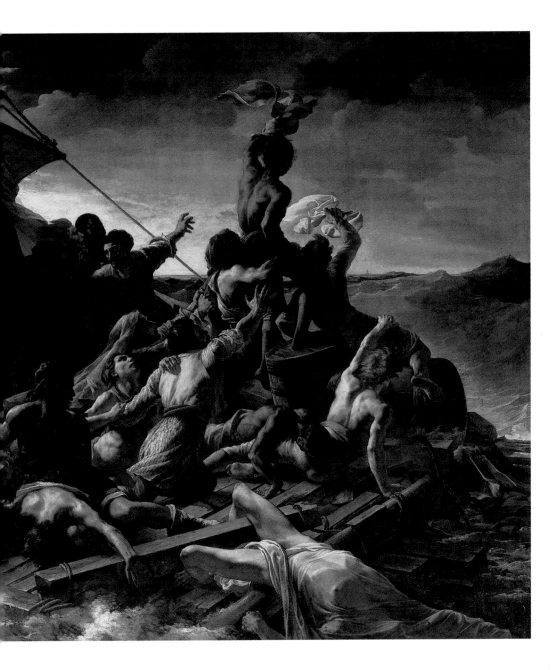

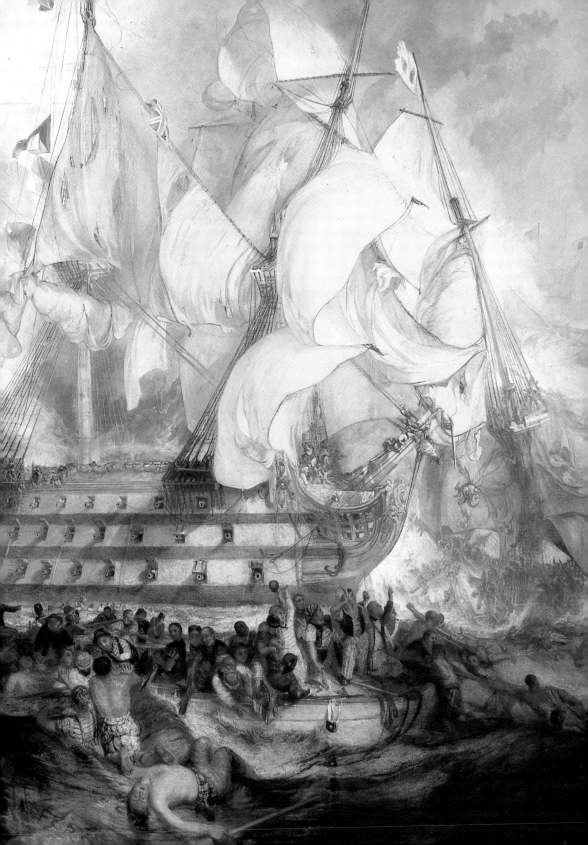

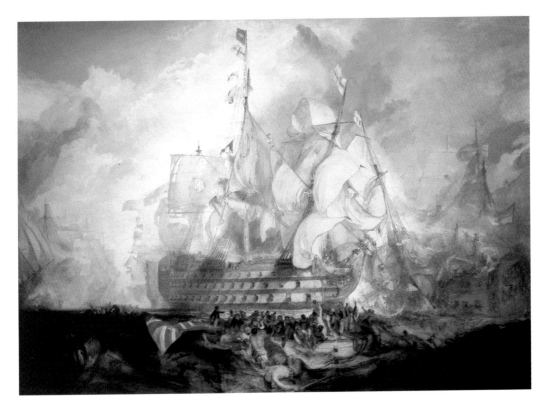

25 Joseph Mallord William Turner
The battle of Trafalgar, 21 October 1805, 1824

Oil on canvas, 261.5 × 368.5 cm
Greenwich, National Maritime Museum

The picture did not please its first audience,
many of them naval officers, not only because
the ships were inaccurately portrayed, but
because, in order to show all he wanted to,
Turner depicted incidents which happened
hours apart as if they were simultaneous. For
example, Nelson's famous message "England
expects..." flown from HMS *Victory* went up
at noon, whereas the *Achille*, sinking in front of
the *Victory*, did not do so until much later.

Detail of 25

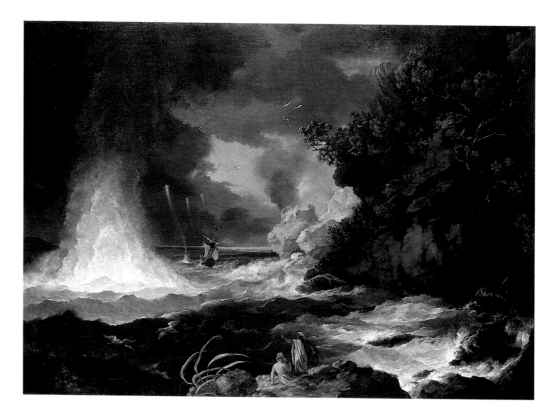

26 William Hodges
HMS Resolution *off Cape Stephens with a*
waterspout, May 1773, c1775/6
Oil on canvas, 136 × 193 cm
Greenwich, National Maritime Museum

Trained as a landscape painter, William Hodges
joined Captain James Cook's voyage in search
of a southern continent in 1772. In pictures
such as this the artist goes beyond his brief to
depict the places visited, instead dramatizing
the predicament of a small vessel at the mercy
of the elements on the opposite side of the
world. Not being a marine artist enables
Hodges to view the tiny frail ship within the
context of the grandeur of nature, without any
wish to portray the details of the ship.

as she then lay in Portsmouth harbor. This
is precisely as she was portrayed by Turner,
who did not realize that at that time she was
unladen, and therefore appeared consider-
ably higher out of the water than she did at
Trafalgar. This and other "inaccuracies" were
immediately taken up by the naval fraternity.
The picture became something of an embar-
rassment, and in 1829 George IV presented it
and the de Loutherbourg to the new National
Gallery of Naval Pictures at Greenwich. It
remains the most compelling depiction of
ships in battle ever painted.

To the Romantic artist the image of the
ship which could carry man to the boundaries
of the known world possessed great potential,
although invariably such images, often wild
and turbulent, were produced in the security
of the studio. However, a remarkable example

is to be found in the little known work of the landscape painter William Hodges, who in 1772 stepped in to accompany Captain James Cook's voyage to the Southern Continent. His brief, quite unremarkably, was to record the places visited. In his bold and colorful depictions of Tahiti and New Zealand Hodges painted exotic landscapes in a way we now consider ahead of his time—his work anticipates that of the Barbizon painters of the 1830s, and Courbet. He sometimes worked on board ship but the larger paintings date from after his return to London. A number of the pictures include Cook's ships, HMS *Resolution* and *Adventure*, for instance one of the most remarkable of them, *HMS* Resolution *off Cape Stephens with a waterspout, May 1773* (**26**), painted later in London. A contemporary written account relates how alarming the appearance of the waterspout was, and its "terrific majesty," which the painting, too,

27 John Wilson Carmichael
HMS Erebus *and* Terror *in the Antarctic*, 1847
Oil on canvas, 122 × 183 cm
Greenwich, National Maritime Museum

John Wilson Carmichael did not accompany Sir James Clark Ross's expedition of geographical discovery to the Antarctic in 1839–1843. This picture is therefore an imaginative reconstruction of what the ships experienced, probably based on Ross's account in his *Voyage to the Southern Seas*, for which the picture was used as an illustration. The *Erebus* (1826) was built as a bomb ketch used for firing mortars during bombardment. As these vessels were, of necessity, particularly strongly built, they were used for Arctic exploration during the 19th century, as they were able to withstand the pressure of the ice. Both these ships later sailed in Sir John Franklin's last fateful expedition to the Arctic, in the course of which they were abandoned in the ice.

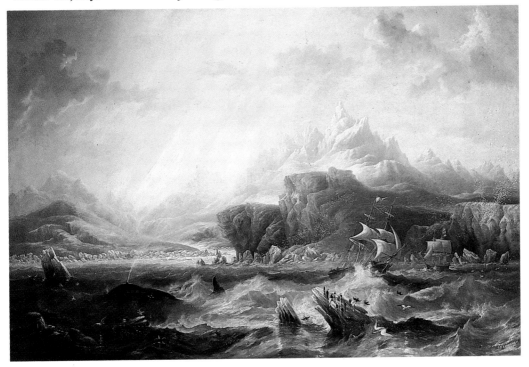

49

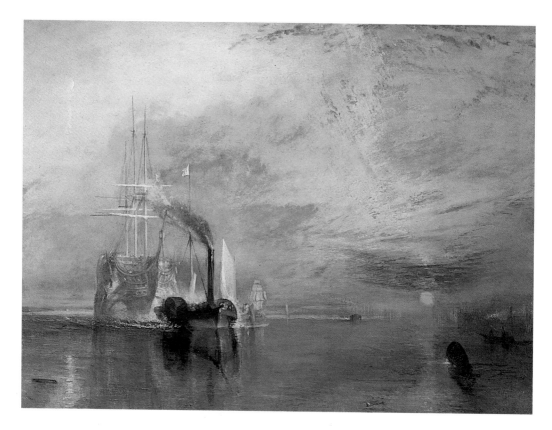

captures. John Wilson Carmichael's later evocation of the Antarctic, depicting Sir James Clark Ross's ships the HMS *Erebus* and *Terror* (**27**) on an 1839–43 scientific expedition to the South Seas, seems almost tame by comparison with Hodges, despite the fantastic light effects and wild mountainous landscape, and although it was painted some 70 years later.

Turner's personal affection for ships and their potential within his pictures are clearly expressed in *The Fighting "Temeraire" tugged to her last berth to be broken up*, 1838 (**28**). This picture should not be dismissed as a sentimental evocation of a past era. It is quite firmly based in fact, and is a portrait of the 98-gun ship, launched in 1798, which had played a distinguished part at the battle of Trafalgar.

28 Joseph Mallord William Turner
The Fighting "Temeraire" tugged to her last berth to be broken up, **1838**
Oil on canvas, 91 × 122 cm
London, National Gallery

Turner witnessed and sketched this scene on a steamer returning from Margate. However, when he came to paint the picture he made changes for which he was criticized. He transposed the positions of the funnel and the foremast of the tug, and showed the *Temeraire* rigged, which she would not have been on this occasion. But this does not belie Turner's affection for the subject—one of the last old wooden ships that had fought at Trafalgar on her way to the shipbreaking yard.

Detail of 28

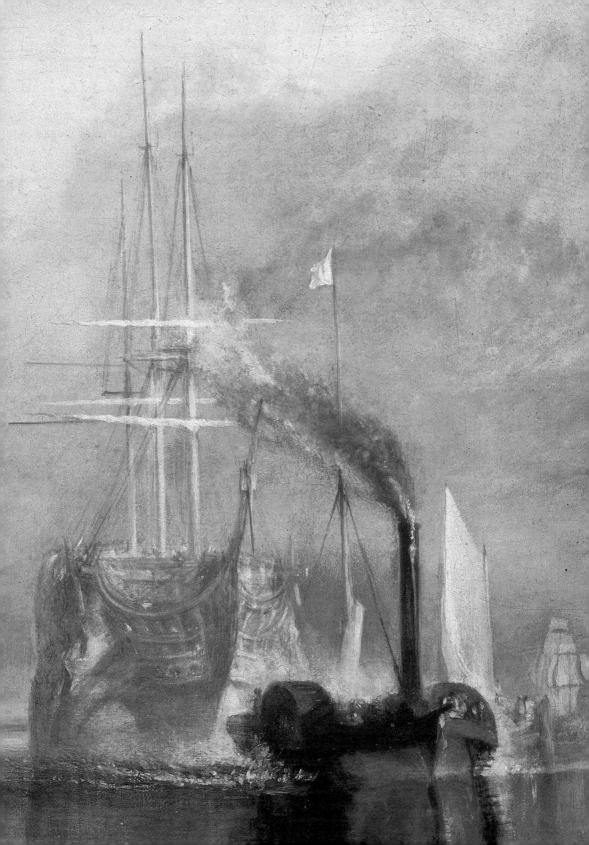

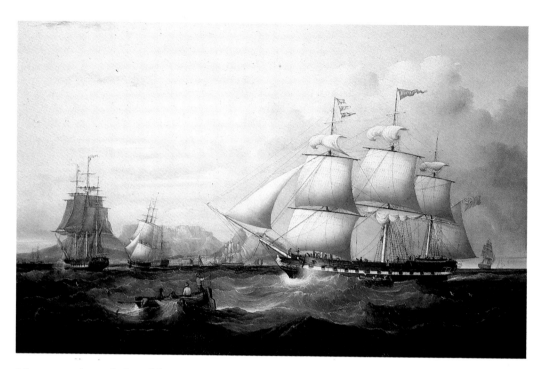

Like a number of the old wooden fighting ships, she had been used for a variety of purposes as a hulk in the Thames estuary—more particularly as a victualing ship at Sheerness. From here, on 6 September 1838, she was towed up the Thames to be broken up at Rotherhithe, and on her way was seen and sketched by Turner, traveling aboard a steam packet returning from Margate, appearing in "a great blazing sunset." The picture was exhibited at the Royal Academy the following year with the lines: "The flag which braved the Battle and the Breeze/No longer owns her." Turner reflects a topical concern of the 1830s, that the ships of the Napoleonic Navy were dwindling. But the picture was also open to a symbolic reading: "A gorgeous horizon poetically intimates that the sun of the Temeraire is setting in glory."

The theme of the decline of the old wooden warships was continued by William Lionel Wyllie, the best known of the British marine

29 Samuel Walters
The Indiaman Euphrates, 1835

Oil on canvas, 96.5 × 152.5 cm
Greenwich, National Maritime Museum

During the 19th century ship portrait painters carried out their business in all the great ports of Europe as well as in the East where native artists operated. Their job was to paint a likeness or "portrait" of a ship for someone connected with her, usually her owner or captain. The viewpoint was generally from the side and the quality of work could vary enormously between artists. The Liverpool artist Samuel Walters was one of the most ambitious, and here paints a recently built Liverpool ship returning from the East.

artists of the late nineteenth century. In *Storm and sunshine, a battle with the elements* (**30**), Wyllie was primarily interested in the effect of light and the weather on the hull of the old HMS *Leonidas* (1807), like the *Temeraire* past her days of active service, and used for the storage of guncotton—"a passing ray of sunlight on a ship's side, whilst the rest of the hull and surrounding water is lashed by wind and rain."

In the work of Continental artists, there is not such a consistent concern with images of the ship as we find in English art of the Romantic period. The one great exception, however, is Géricault, who, in his *Raft of the Medusa*, created one of the greatest images of tragedy at sea, both heroic and political in its message. And yet it is not an image of a ship at all: as the survivors cling to their makeshift raft, with its mast and sail the simplest form of craft, only the sails of the rescuing ship can be seen far off on the horizon. The energy and

30 William Lionel Wyllie
Storm and sunshine: a battle with the elements,
1885
Oil on canvas, 106.5 × 183 cm
Greenwich, National Maritime Museum

During the 1880s the old wooden fighting ships were part of Wyllie's surroundings near his home on the river Medway. Wyllie uncompromisingly depicts the *Leonidas*, used for storing guncotton, as men work on her and a squall comes down. There is no attempt to disguise the raw conditions of the activity and the subject is treated without sentimentality.

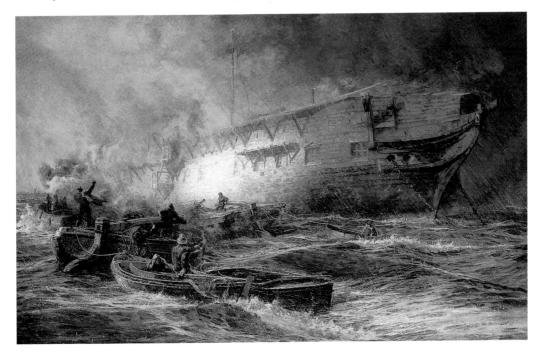

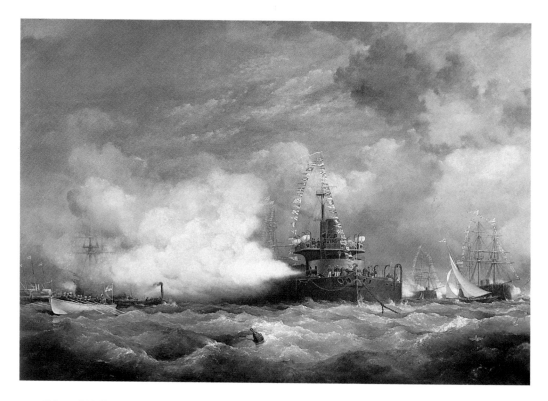

31 Edward William Cooke
The Shah of Persia reviewing the fleet with HMS
Devastation, 13 June 1873, 1875
Oil on canvas, 139.5 × 205.5 cm
Greenwich, National Maritime Museum

Cooke relished depicting all the technical detail
belonging to ships. The Shah is in the Royal
Yacht *Victoria and Albert* on the extreme left
and the ship in the foreground is the
Devastation, the first mastless battleship to be
built for the Royal Navy, firing a royal salute.

the horror of the picture is concentrated upon the dreadful state, both physical and psychological, of the men and women and their cruelty to each other in this predicament. Rather like Turner and the *Battle of Trafalgar*, Géricault took enormous pains to research his subject. He interviewed and made portraits of the survivors, built and tested a raft in the sea, and he visited the Hôpital Beaujon to make studies of corpses and limbs.

Perhaps one of the most unlikely marine paintings to come out of France is Manet's *Battle between the* Alabama *and the* Kearsage, *18 June 1864* (Pennsylvania Museum of Art), a naval action between opposing sides in the American Civil War which Manet himself may have witnessed taking place off the coast near Cherbourg. The moment shown is the Confederate *Alabama* sinking as a boat goes out to pick up survivors—a subject which might have been painted by any eighteenth-century English marine painter, but which in Manet's hands is treated entirely unconventionally.

Ceremonial events continued to provide the artist with the opportunity to paint ships both in England and France. On 23 June 1873, the Shah of Persia on a visit to England, where he was entertained by Queen Victoria with unprecedented splendor, watched a review of the British fleet carried out in his honor at Spithead on the south coast. The review was painted by the marine artist Edward William Cooke, who, being particularly fascinated by all kinds of mechanical detail, took as his subject HMS *Devastation*, the first battleship without sails to be built for the British Navy. Fifteen years earlier the French painter of landscape and coastal views, Jules Noël, had turned his hand to a similar subject, *Napoleon III receiving Queen Victoria at Cherbourg, 5 August 1858* (**32**). The queen has just left her yacht the *Victoria and Albert II*, in which she

had crossed from England to Cherbourg, and is about to board the *Bretagne*. The artist is concerned to convey the color and ceremony of the occasion, as well as making a ship portrait, using the flagship to add tremendous scale to the picture. The French artist James Tissot, working in England in the late nineteenth century, used ships as a deliberate pictorial device. In *Portsmouth dockyard, c1877*, the theme is a soldier choosing between two pretty women as the three sit in a boat in Portsmouth Harbor. Two hulks tower behind them, one of them possibly HMS *Nelson* of 1814.

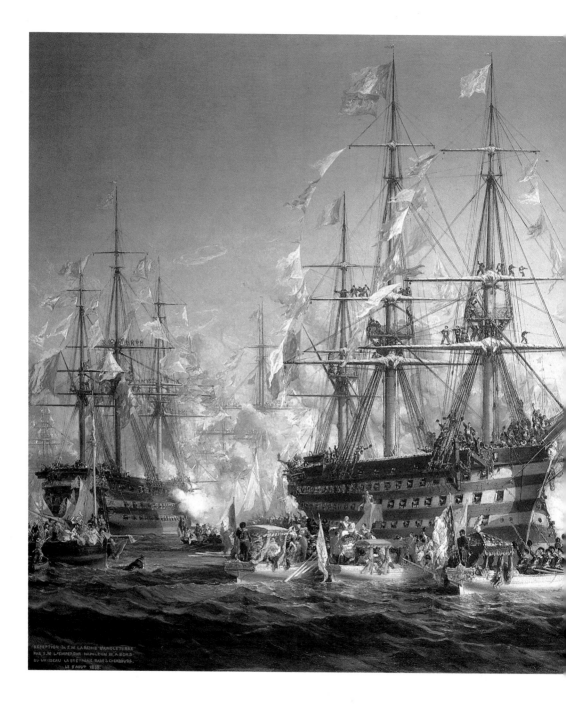

RECEPTION DE S.M. LA REINE D'ANGLETERRE
PAR S.M. L'EMPEREUR NAPOLEON III, A BORD
DU VAISSEAU LA BRETAGNE, RADE DE CHERBOURG,
LE 5 AOUT 1858.

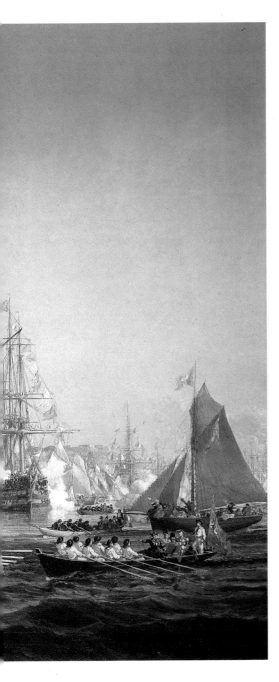

32 Jules Achille Noël
Napoleon III receiving Queen Victoria at Cherbourg, 5 August 1858, 1859
Oil on canvas, 165 × 228.5 cm
Greenwich, National Maritime Museum

Queen Victoria and Prince Albert sailed to
Cherbourg in their new yacht the *Victoria and
Albert II.* "At seven o'clock the barge of Her
Majesty the Queen of England left the Royal
Yacht and pulled towards the *Bretagne* . . .
where the emperor received his august guest at
the foot of the companion ladder of the
Bretagne". Normally a painter of coastal
landscapes, Noël manages to convey the color
and splendor of the occasion, and does not
shirk the painting of the ships in their entirety.

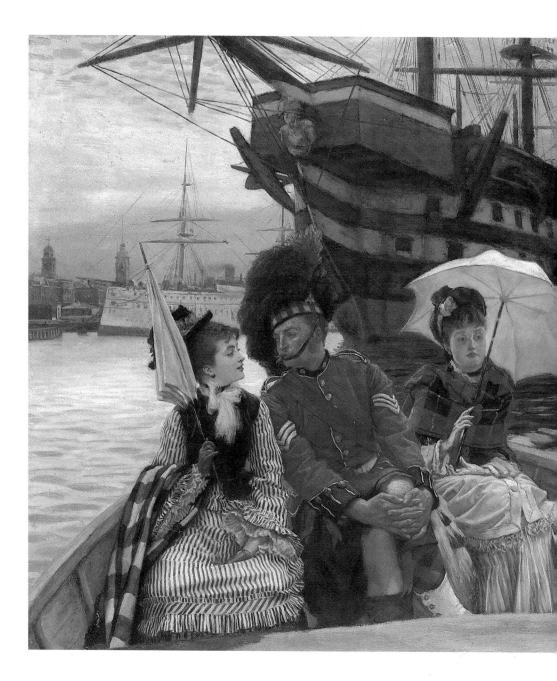

The twentieth century

33 James (Jacques Joseph) Tissot
Portsmouth dockyard, c1877
Oil on canvas, 38 × 54.5 cm
London, Tate Gallery

Large ships, battles, and ceremonial occasions were not, in general, the kind of subject with which the major international art movements of the late nineteenth and early twentieth centuries were concerned. Ships, however, appear in the works of Eugène Boudin and Albert Marquet. Steam boats often find their way into André Derain's paintings. But perhaps the most memorable depictions of ships are to be found in the paintings of James Tissot, who used them as both background and setting for his elegant figures (**33**).

In the twentieth century, however, the two World Wars stimulated once again some stirring images of ships. War artists officially appointed to record events were often accomplished painters who could bring a freshness of vision to what they saw, as opposed to the work of specialist marine painters whose attitudes remained rooted in the old tradition of accuracy for the sake of accuracy, an outlook which remains dominant to this day.

Not only did these artists record ships, but they also made a positive contribution in the invention and practice of "dazzle painting", later called "camouflage". "Dazzle painting", which involved painting the hulls of the warships in bold geometric patterns, in order to cause visual distortion and therefore to confuse the enemy, was invented by the marine artist Norman Wilkinson. As an unofficial war artist working within the Royal Navy the Scottish artist John Duncan Fergusson saw and painted dazzle-painted ships in Portsmouth Harbor in 1918 (**34**), and the boldly painted designs held a special fascination for a number of artists, notably John Everett and Edward Wadsworth, in whose work these shapes developed a life of their own.

The ability of an artist to transform a ship in

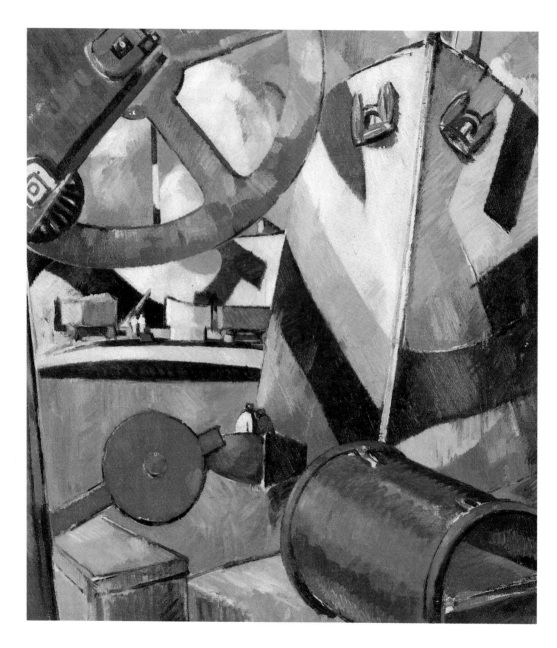

action into an exciting surface of textured paint is well demonstrated in the work of Richard Eurich who worked as an official war artist from 1941 to 1945. In *Bombardment of the coast near Trapani* (**35**) he has brought together both the observation of the Van de Veldes and the color, space, and atmosphere of Turner. Indeed Eurich saw himself continuing the traditions of these artists. Charles Pears, on the other hand, who worked as an artist for the Admiralty during the First World War, and again as an official War Artist during the Second, was essentially an illustrator, who produced posters. The qualities associated with this kind of work can be seen in his painting *The passenger liner* Queen Mary *arriving at Southampton, 27 March 1936* (**36**), in which the newly built Cunard White Star liner arrives from Clydebank to be finished at Southampton by the ship's mechanics and carpenters who wait for her in the foreground.

The inclusion of figures in paintings of ships is one of the most significant concerns of twentieth-century artists, who, coming from broader disciplines, were eager to portray what it was actually like to live and work on a ship, rather than simply to portray the ship's outer shell. They provided the interesting detail which artists of earlier centuries largely ignored (perhaps because life on board ship was then so unpleasant). Depicting life on board a submarine offered a special challenge for the artist, at the same time stimulating unconventional compositions as in Stephen Bone's *"Up the conning tower": on board a submarine, 1944* (**38**). Stanley Spencer's series of paintings of shipbuilding on the Clyde provide a detailed account of the trades involved in shipbuilding in the 1940s—and a modern parallel with what John Cleveley or Joseph Vernet recorded in their pictures of dockyards two hundred years earlier.

34 John Duncan Fergusson
Dockyard, Portsmouth, 1918
Oil on canvas, 78 × 70.9 cm
London, Imperial War Museum
Not only was dazzle painting invented by a marine artist, Norman Wilkinson, but dazzle-painted ships had a particular fascination for artists who enjoyed painting their bold designs.

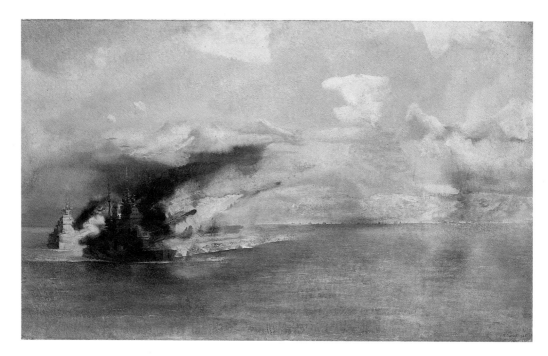

35 Richard Ernst Eurich
Bombardment of the coast near Trapani, Sicily,
by HMS King George V *and* Howe, *12 July*
1943, 1943
Oil on canvas, 76 × 127 cm
Greenwich, National Maritime Museum

36 Charles Pears
The passenger liner Queen Mary *arriving at Southampton, 27 March 1936,* 1936/7
Oil on canvas, 101.5 × 127 cm
Greenwich, National Maritime Museum

Pears here depicts a new ship, a national status symbol. Along with the French *Normandie* this 81,000-ton liner represents the ultimate in size and comfort for ships on the pre-war North Atlantic run. Her decorations were contemporary and lavish, and executed by a team of some of the country's leading artists. Here the ship's mechanics and carpenters who were to complete her look on as the liner arrives.

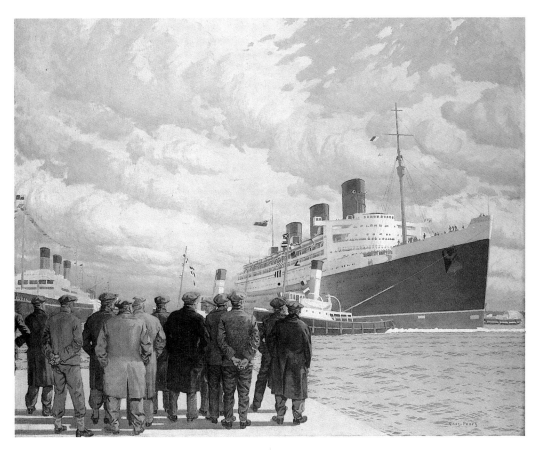

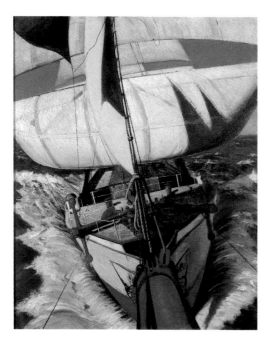

37 Herbert Barnard John Everett
Deck scene (from the bows), 1920s
Oil on canvas, 65 × 46 cm
Greenwich, National Maritime Museum

While there are instances of sailors changing
their profession to become marine artists, John
Everett provides an example of the opposite.
Having trained as an art student with Augustus
John, Everett then went to sea on board the last
merchant sailing ships and produced such
startling images as this one.

38 Stephen Bone
"Up the conning tower": on board a submarine,
1944
Oil on canvas, 77.5 × 65 cm
Greenwich, National Maritime Museum

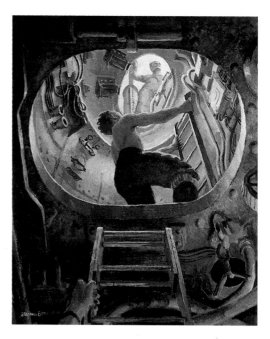